Bloopers
on Paper

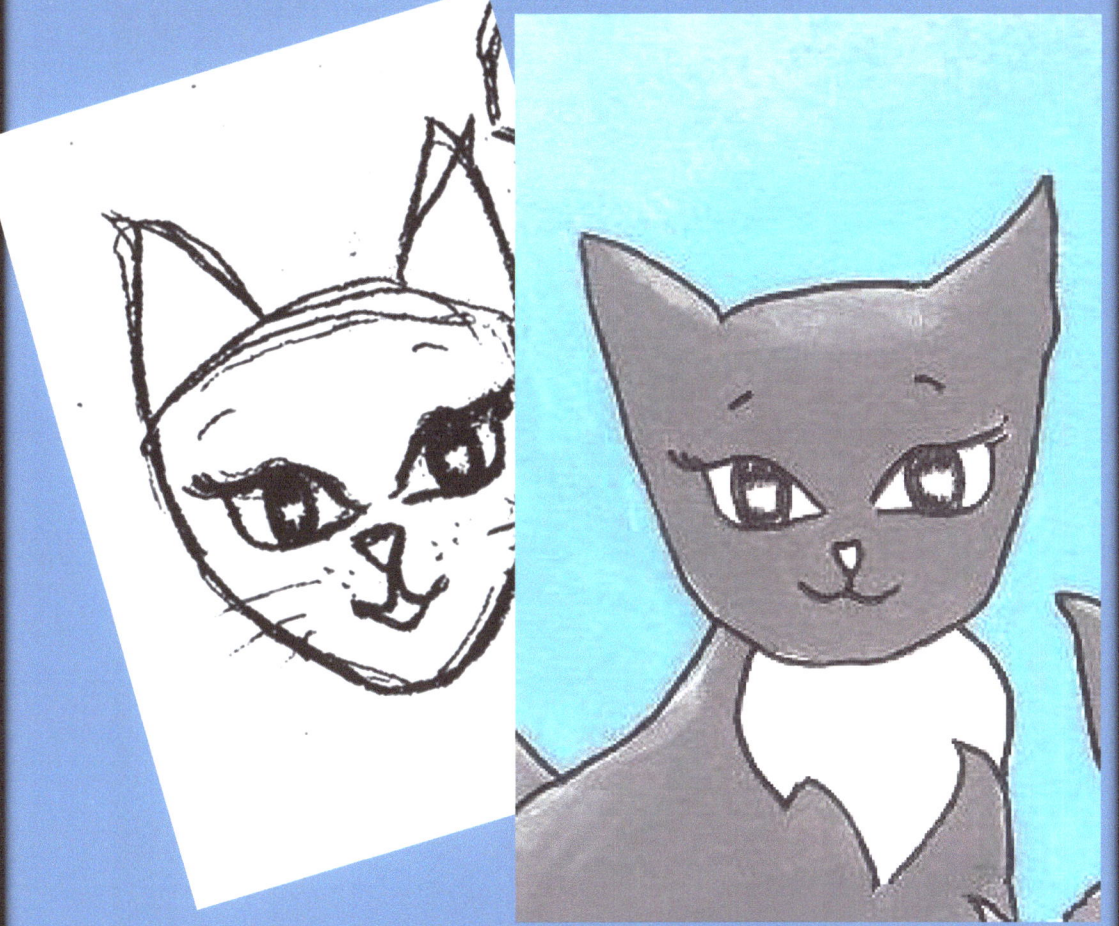

For amateur illustrators,
a short how-to guide
for making your own children's book

Sydney Pelletier

Works by Sydney Pelletier

(available on Amazon)

Kids
Kitty and Company
King Sunny and the Rainbow
The Little Book of Halloween
Ready for Christmas!
The Wizard and the Star

Young Adults
Overdose
Post-trip

Adults Non-fiction
Bloopers on Paper

Adults Fiction
Obsidian Drones

Illustrations and copyright
© 2017 Annie Poitras
6000000-1430301-0101128
All rights reserved

Table of Contents

Preface ... 5
Getting started .. 6
Different faces ... 10
Background influences .. 11
Color patterns ... 12
More facial expressions ... 13
Page design, again ... 14
Font choices .. 15
Picture options ... 16
Using real pictures ... 17
Copyrights ... 18
Real pictures, part two .. 20
Problems with the canvas ... 21
Real paint... Real pain .. 22
Painting in Layers ... 26
Painting in Layers, an encore ... 27
Now it's your turn! ... 29

Preface

I'm not a professional illustrator. I never took a drawing class, never learned how to paint and still struggle with the subtle balance of light and shadows. Bound by the constraints of dime and time, I illustrated my own children's books out of necessity; I wanted to tell the stories and needed images to highlight the texts but couldn't afford the services of a real, actual, professional illustrator. Hereinafter are my attempts at getting the work done despite my limitations, and my awareness of these limitations. Working by trial and error, and finding solutions to what I often thought were insurmountable obstacles, I plowed ahead on sheer desperation, some audacity, and the notion that if I loved what I was doing, it would all work out in the end.

In the hopes that this little guide may assist you in your own endeavors, help you avoid problems or even provide inspiration, here then are my sketches for children's books, ages 3 to infinity.

Enjoy!

Sydney Pelletier

Getting started

Getting the story right is not only the first step in making your own children's book, it's also part of the drawing process. Once you know who your characters are and where the action takes place, you can begin to think about important plot points you'll want to illustrate.

Dividing the story

One good way to start is to choose a specific layout. Try to see what fits best: landscape or portrait orientation. This decision will affect how you place events and characters on the page, sometimes directly influencing your storyline. I tend to choose landscape layouts for pre-schoolers, and portrait layouts for more mature readers; obviously, the less words you have, the more important your images will be. A landscape orientation might accommodate large drawings more kindly, but the portrait option will be easier to print out, should you ever want a hard copy of your book. As always, go with your instincts, and choose the option you think will best showcase your story.

Landscape (original was 13.5cm x 35cm):

Portrait
(original was 21.5cm x 28cm):

Sunny walked all morning.

He soon came to the second and warmest city

in his island, the City of Summer.

The King thought it was very beautiful!

 Everywhere birds were chirping,

the grass was thick and swaying,

and all the people were having fun swimming.

Once you've decided on a design, think about dividing your story into pages. Again, this might look like an obvious point to make, but tailoring your story to be a "page turner" can be trickier than it seems. Try to make plot points fit with end of pages, giving your story the balance and delivery-delay it deserves. Remember, you'll be able to use drawings to space out your text.

This brings us to the next decision you'll want to make: does your story call for a separate layout (text and images side-by-side) or an overlapping layout? In the following examples, note the design and composition – and those end-of-page teasers!

Overlapping:

Separate:

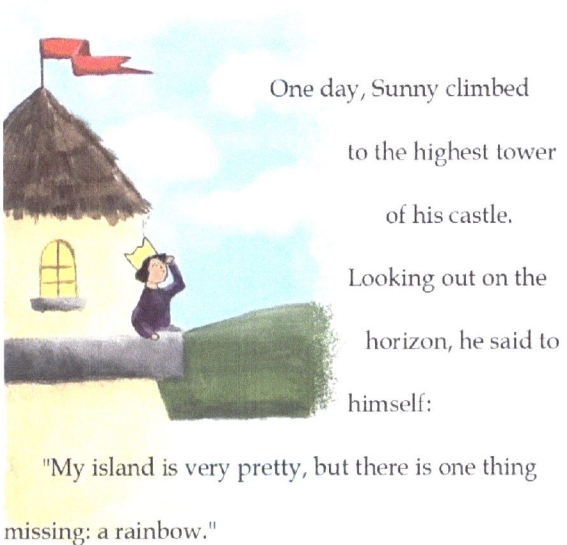

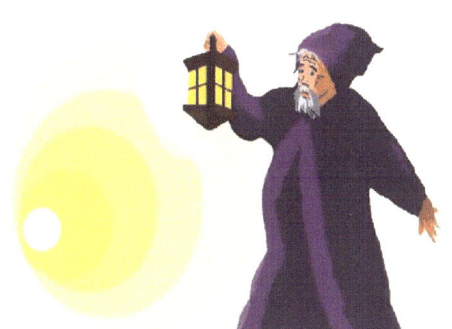

A separate layout tends to work great when you have a lot of text, but again, trust your better judgment. Best case scenarios should serve both form and content, bringing out key features in the drawing, and emphasizing plot points in the story. Image and text should never interfere with one another, but instead complement each other. Although this sounds easier said than done, it's often just a matter of "creative tweaking": don't be afraid to try out ideas on the page, testing out different versions and combinations until you hit that moment when things seem – and feel – just right.

The characters

Determining who the characters are and what they look like is a delightful part of the children's book creation process. You get to decide if your characters will look realistic, cartoonish, naïve or elaborate, depending on your level of drawing skills. In writing, we already have a mental picture of our characters, and know, for instance, that they have light-colored hair, or wear a hat, or hold a cane. These are important flag points, which can later be used to anchor a specific character into a story, or many other stories if you're thinking about doing a series. Knowing if your characters will be recurring figures, or part of an ensemble cast of varying entities is also crucial. Have fun with your creations and let yourself be guided by them.

In *King Sunny and the Rainbow*, the King is a recurring figure, but the people he meets along the way are interchangeable entities.

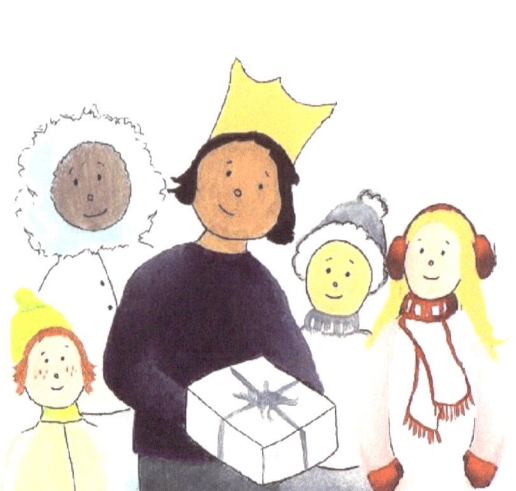 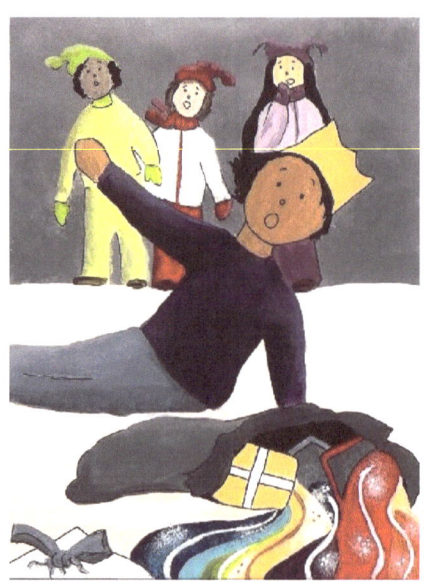

In my Halloween book, I chose to keep the same characters throughout even though this was a vignette-type album and not a character driven story. I had fun using the same characters and seeing them change when they got into their costumes to go trick-or-treating.

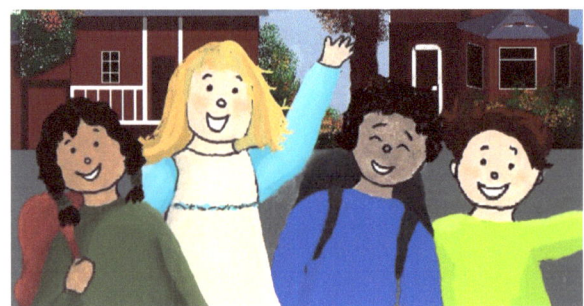 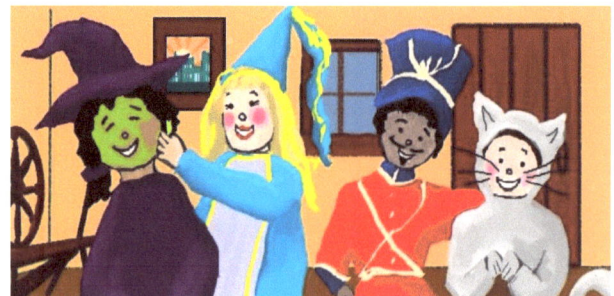

The background

Getting the background right is never easy. After I've decided how to shape my story and who my characters are, deciding on a background is often where I get stuck. Context should be interesting but not too busy, as it will take away from the main action.

Now as a case in point, I started this sketch for a background in a trick-or-treating scene. As elaborate as it promised to be, it didn't serve the story and detracted from the main characters, so it had to be shelved. Don't be afraid to throw away good ideas or nice scenery; they may come in handy in some other project and fall naturally into place there.

Busy background:

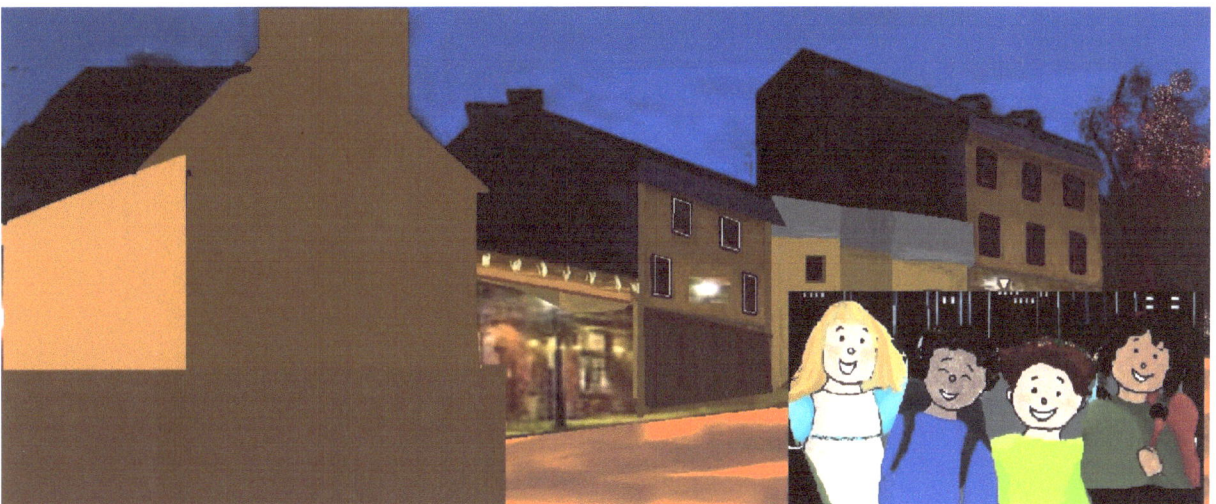

Simpler background, and more focus on the main characters:

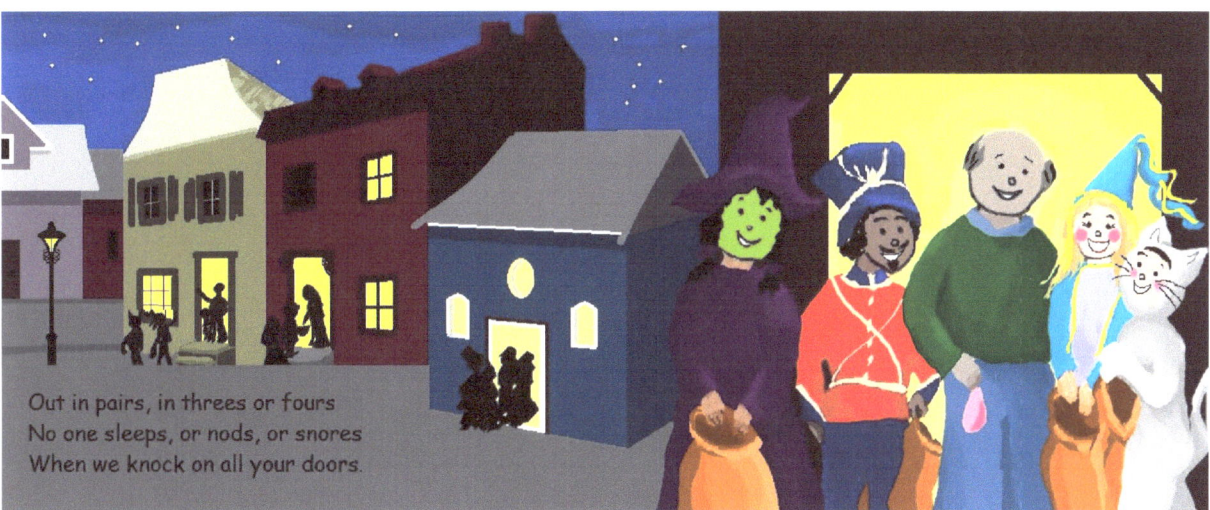

Another fun addition for me was when I put a reversed likeness of the Big Dipper in the sky. I like these little, almost hidden details.

Different faces

It took me a while to figure out the right facial features for the cats in *Kitty and Company*. Of all my projects, this is the one that gave me the most grief. It was really a case of hit-and-miss until I found what I wanted. I took inspiration from cartoons and comic books, my cats and my own facial expressions…

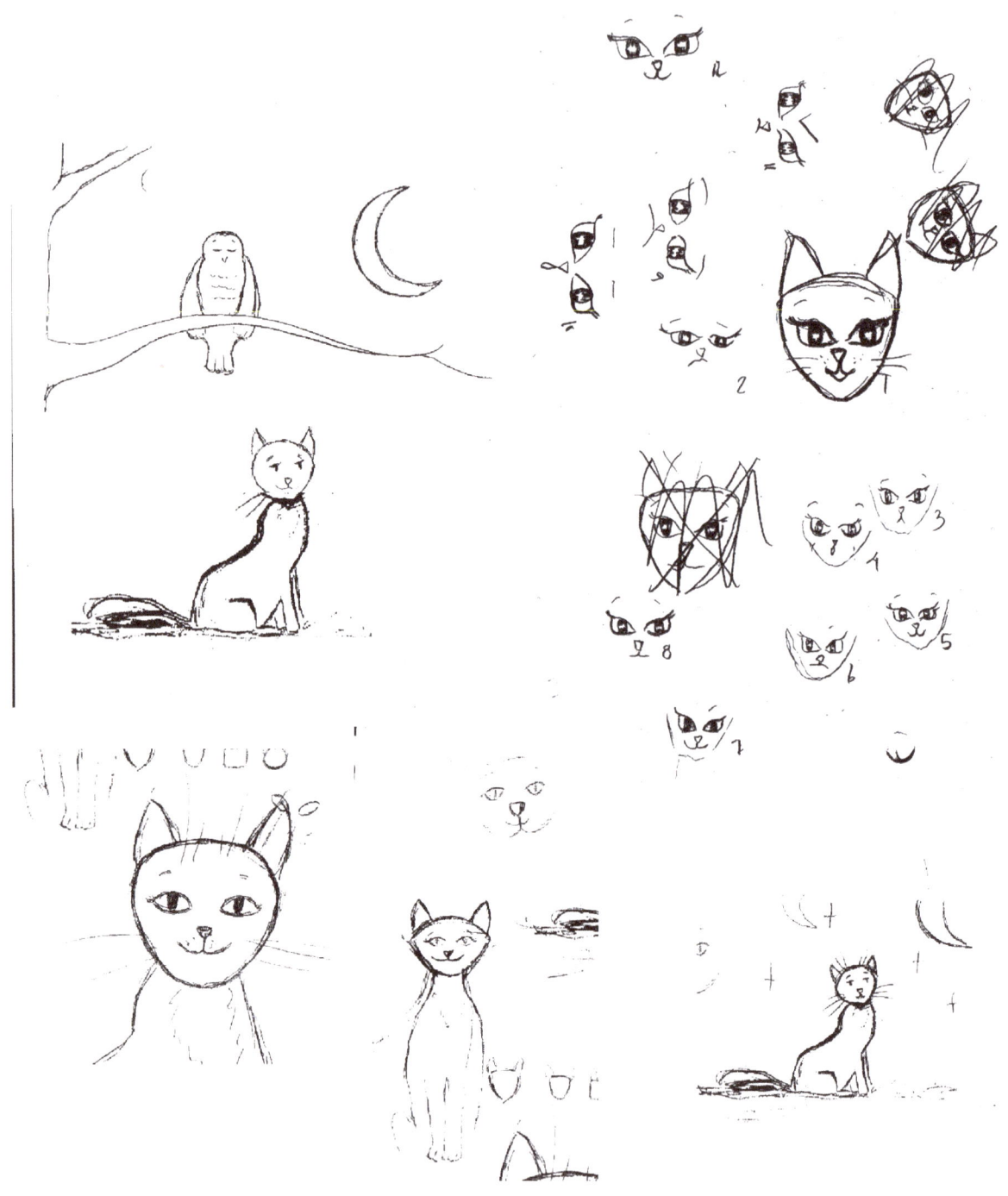

Background influences

I never realized the importance of flourishes in décor until I tackled my first book. I had done covers before, but they had to be instantly revealing, so I packed as much info into them as possible. I found that to be counter-productive in children's books. The classic expression "less is more" definitely applies here. Too many features can take away from the central characters and the story you're trying to tell.

I thought my first draft for this cover was too busy. The title got lost and the focus was all wrong:

I used that drawing on the last page instead, when the story culminates in the land of plenty:

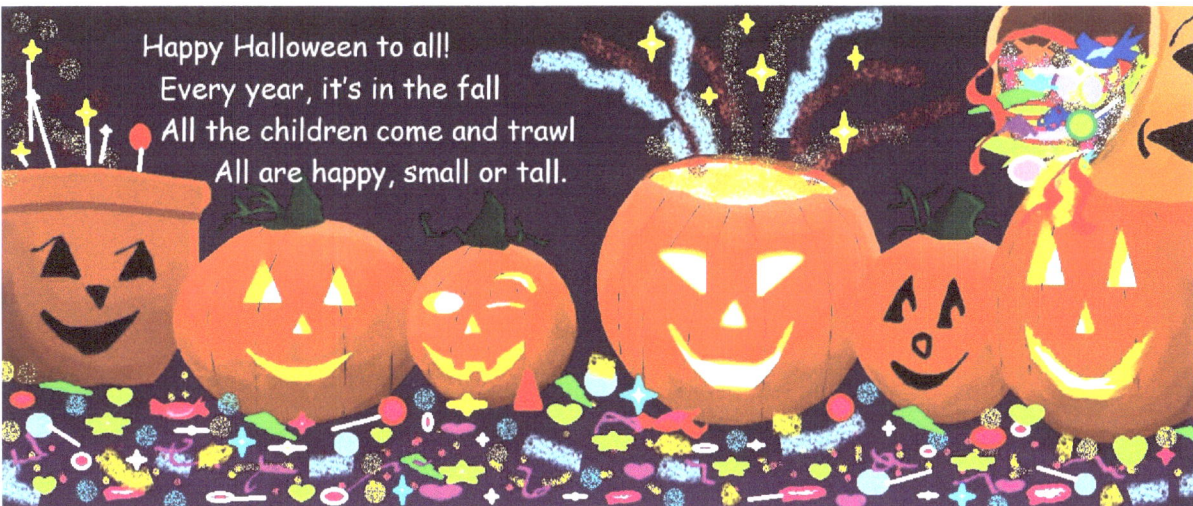

Color patterns

For me, tweaking colors can be a long, arduous process. In this sketch, I thought the characters lost a lot of gleam when, ironically, the colors I chose for one of them turned out to be too pale.

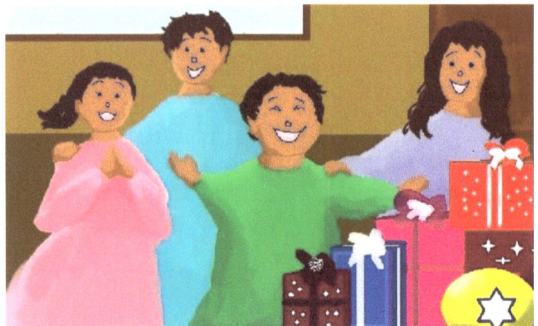

Here, I preferred to let the city recede into a quasi-monochrome background and put the focus instead on the main characters and their bags full of treats.

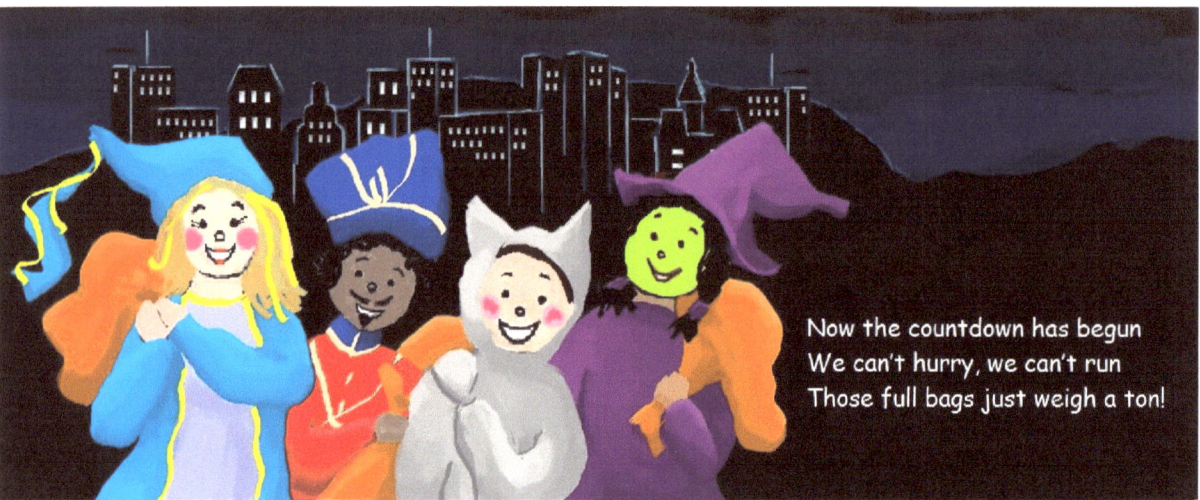

Another example of color tweaking: Final version:

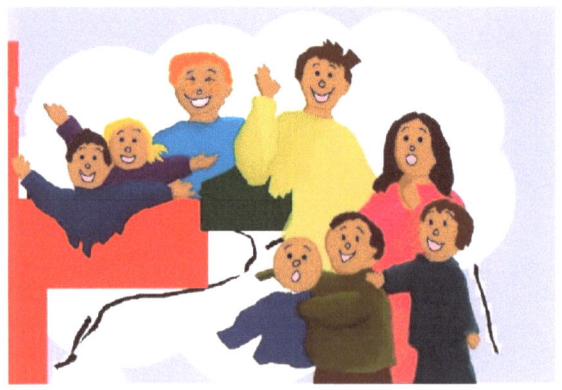 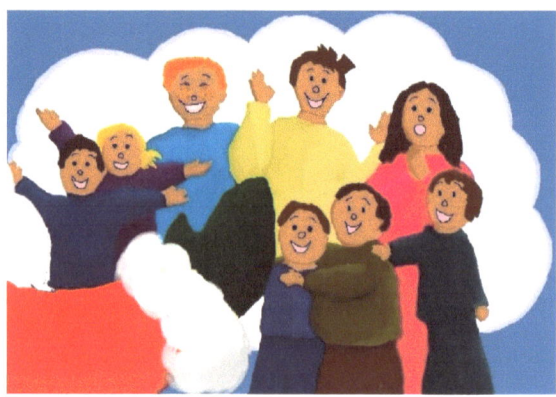

More facial expressions

In this first draft, the Star's face didn't quite convey the tenderness I needed for the big "revelation scene" in *The Wizard and the Star*.

Before:

After:

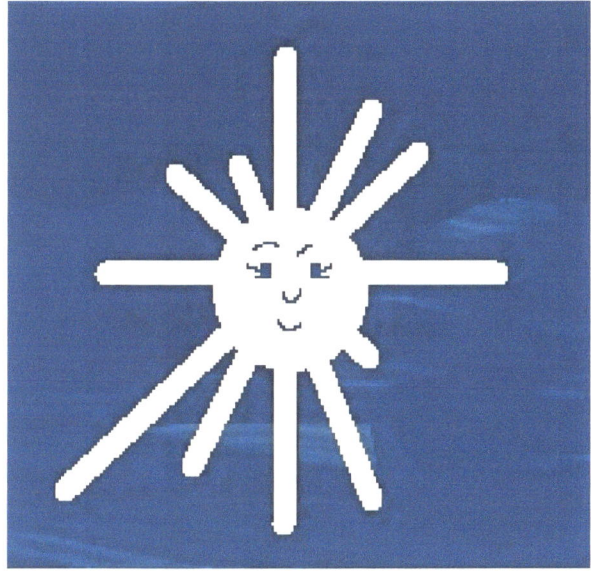
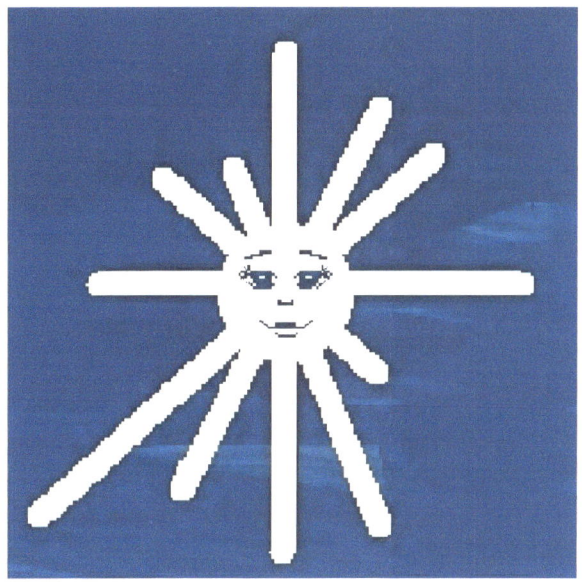

The same problem occurred with this character. I found the drawing much more eye-catching when the character looked directly at us. This small change gave me a deeper sense of connection with the story.

Before:

After:

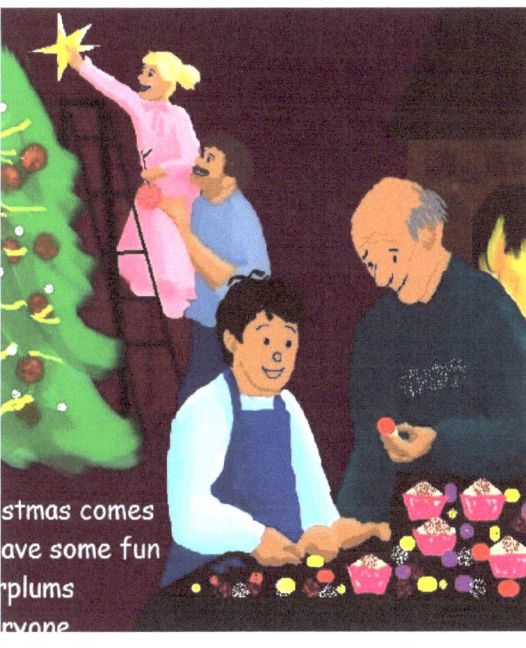
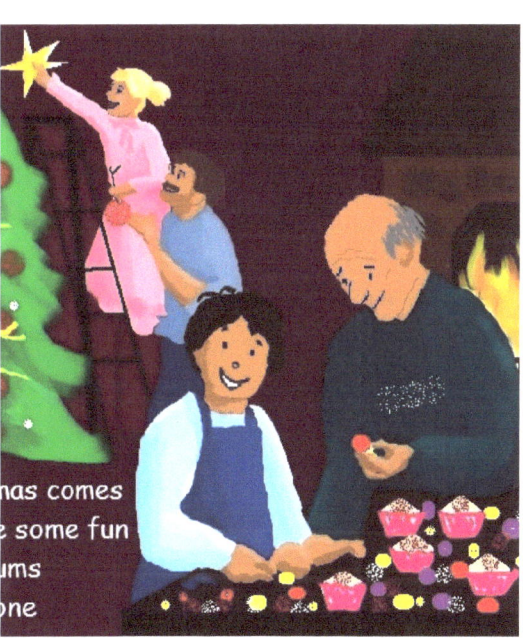

Page design, again

Finding the right page design can be a many-detoured journey, for there is, arguably, no "right" page layout. Possibilities are endless, and a matter of taste. Finding what works for you (text aligned, unaligned, picture centered, off-centered, etc.) is what really counts. When working with Word, I find viewing the whole page, and then using the Picture Tools guidelines, most helpful (Picture Tools become available once you click on the image you've imported).

One possibility: off-centre, but with too much emphasis on the window

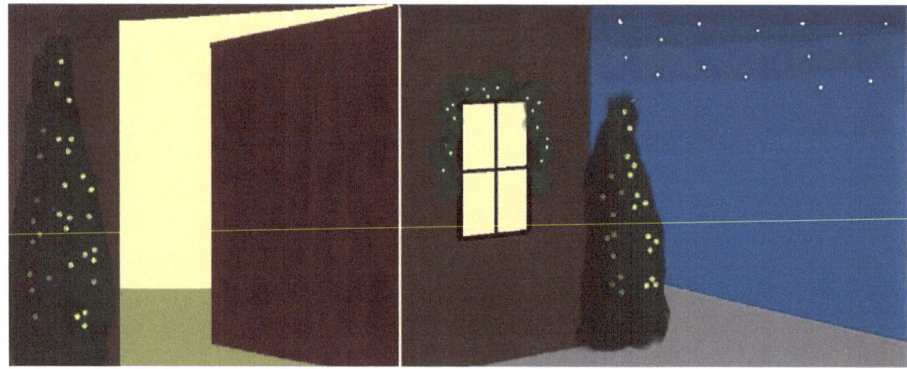

Another attempt:

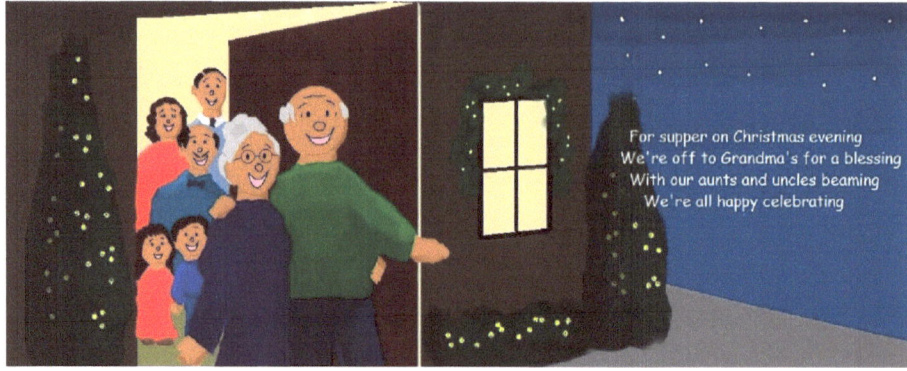

Final version: more trees on the left, less wall on the right, snow added and white to highlight the hair.

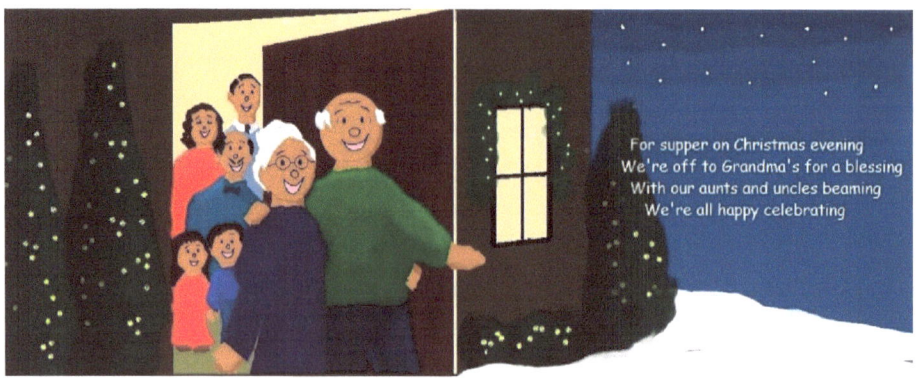

Font choices

For children's books, the font Comic Sans MS works well, but it may get a little redundant over time... While I usually prefer simple, clear titles, I decided to keep the aforementioned Comic Sans MS font for the Halloween cover, but selected and dragged down the word "Halloween" to give it that gloom-and-doom feel.

The famous Comic Sans MS:

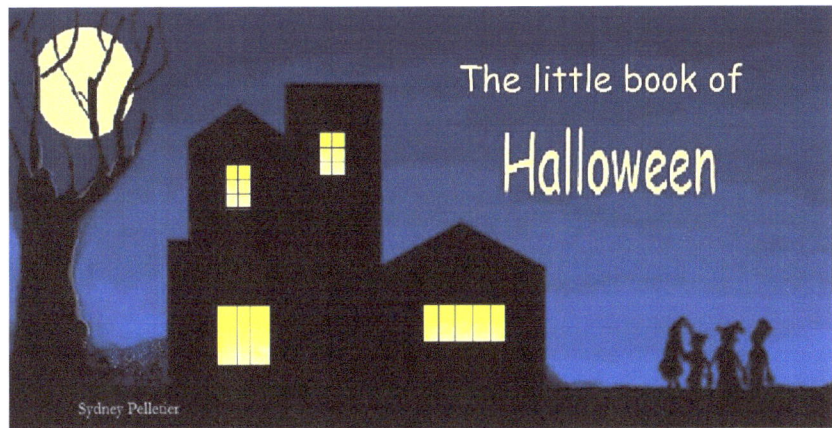

For *Kitty and Company*, I used the font Bradley Hand ITC and played around with the title by bending it slightly to "snuggle" the characters. For *The Wizard and the Star* I thought a more medieval-looking font would work well, but then found it was too distracting if I used it in the book itself. I kept the font for the title (Tempus Sans ITC), but reverted to classic Times New Roman for the body of the text. Papyrus would also have worked well for this title.

Bradley Hand ITC: Tempus Sans ITC:

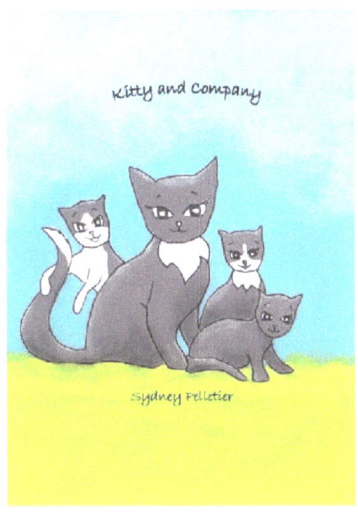
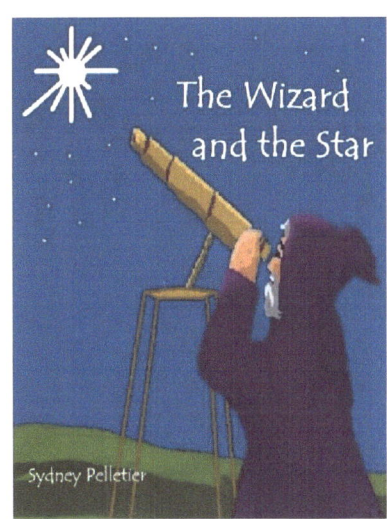

On a side note: you can see I used real acrylic paint for the Kitty book, and the Paint program on my PC for the Wizard. I myself prefer the Kitty cover. But more about that later...

Picture options

I find borders options interesting, but some of them don't come out right once the book is converted for publication. I had the same problem when I used picture texture options, especially the "diffuse glow" artistic effect. The "film grain" option worked well, however, and I used it in *The Wizard and the Star* when the Wizard has flashbacks.

Original picture:

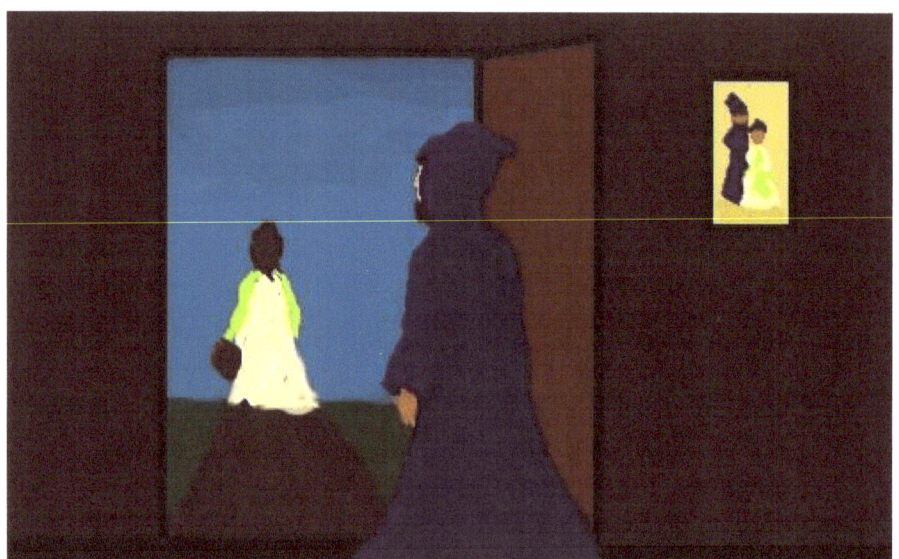

With the "film grain" artistic effect:

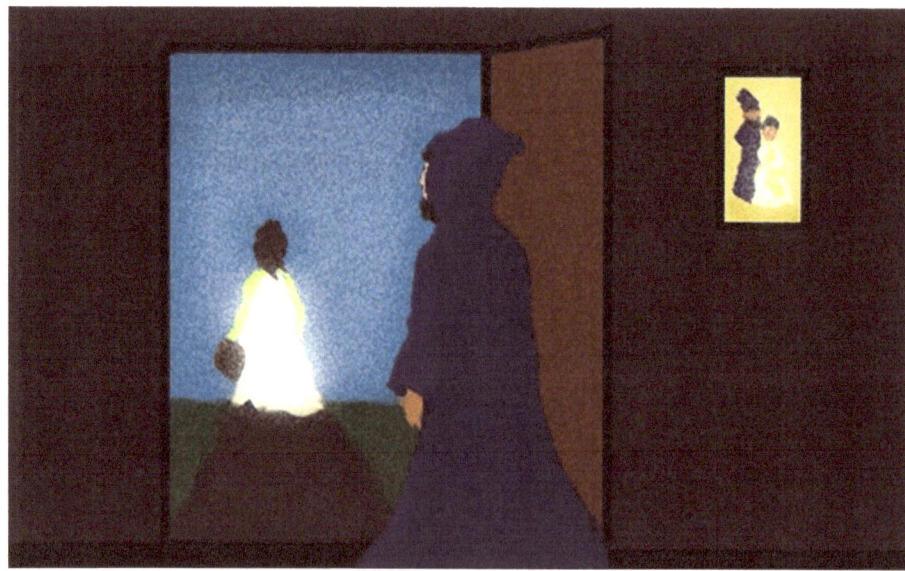

Using real pictures

When illustrator's block strikes (as it often does), I sometimes look for real pictures to help me get out of the quagmire. I took inspiration for a drawing from this picture of a lost dog – poor soul.

Actual picture (from the website Animal Blog):

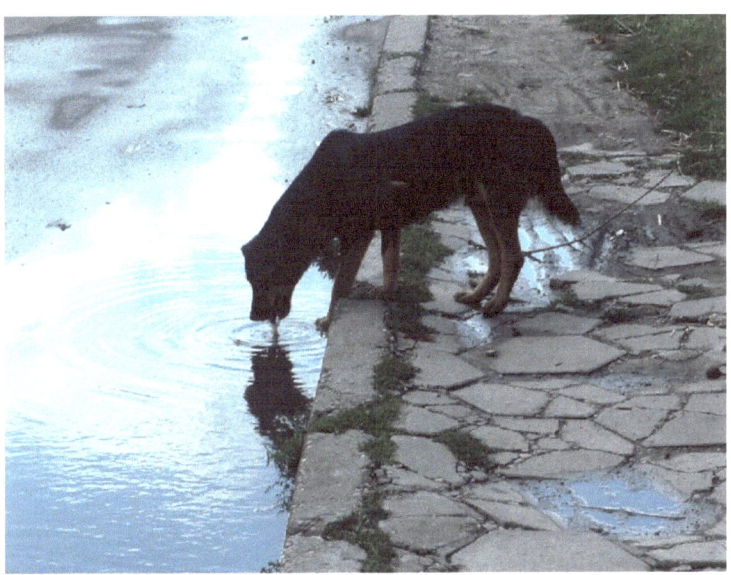

My drawing, using key features:

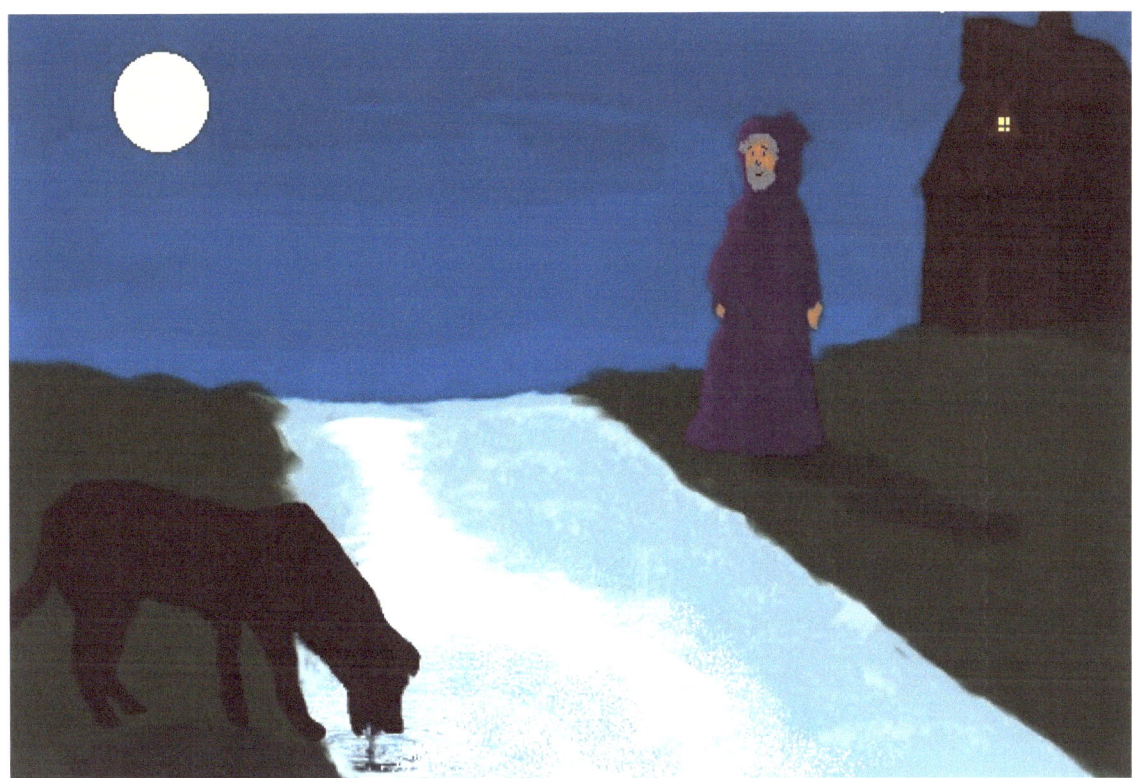

Copyrights

If you take pictures from the Internet, beware of copyrighted material – name your sources! I actually copied my own work when I included the Kitty character in *Ready for Christmas*. I liked her there and had no qualms about infringing my own copyright...

Can you spot Kitty? Simple copy/paste here.

I also used one of the nameless characters from *The Little Book of Halloween* and placed him among family members in *Ready for Christmas*. I like seeing recurring faces and figures in my books; I feel it gives the collection a sense of cohesion.

In the Halloween book: In the Christmas book (copy, paste... and horizontal flip!):

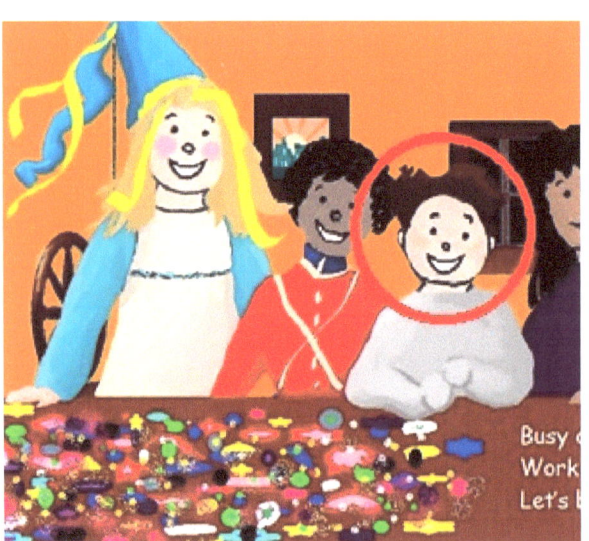
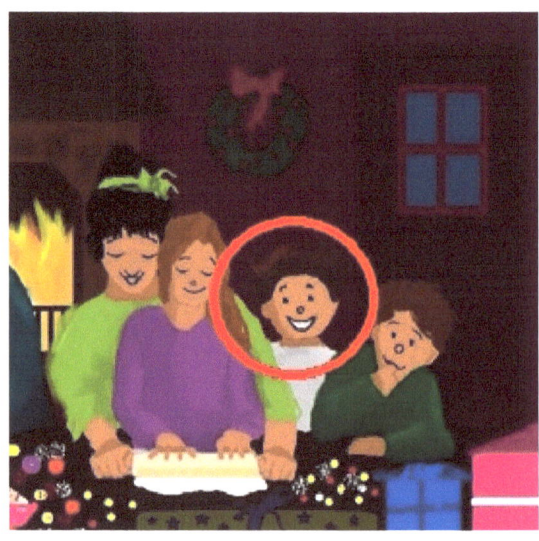

Another amusing repeat for me was sampling the houses from one of my books and transposing them in a wintertime setting. I had fun decorating the houses for the holidays and giving that image a new spin.

The original drawing:

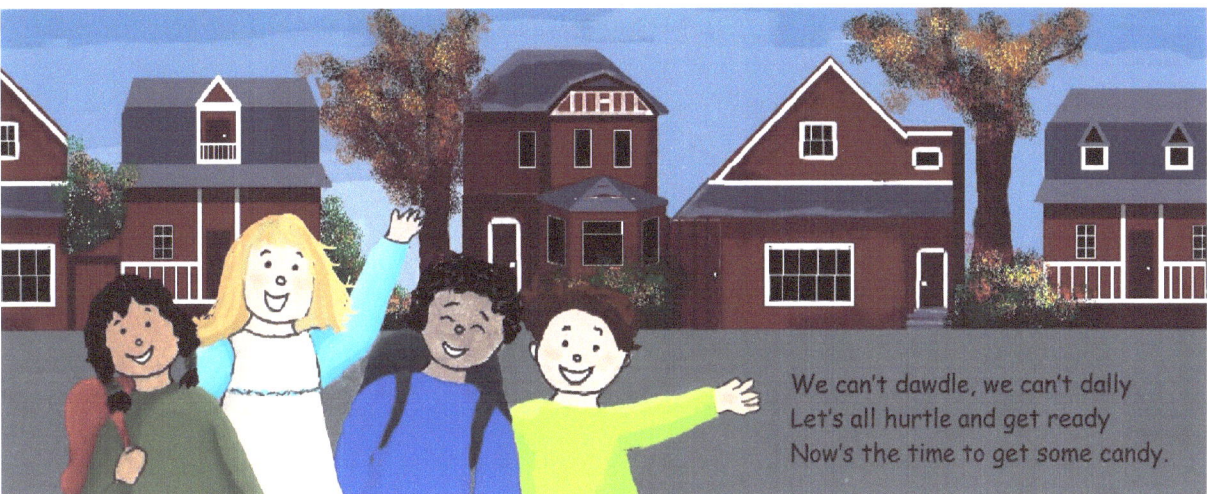

The "wintertime" version:

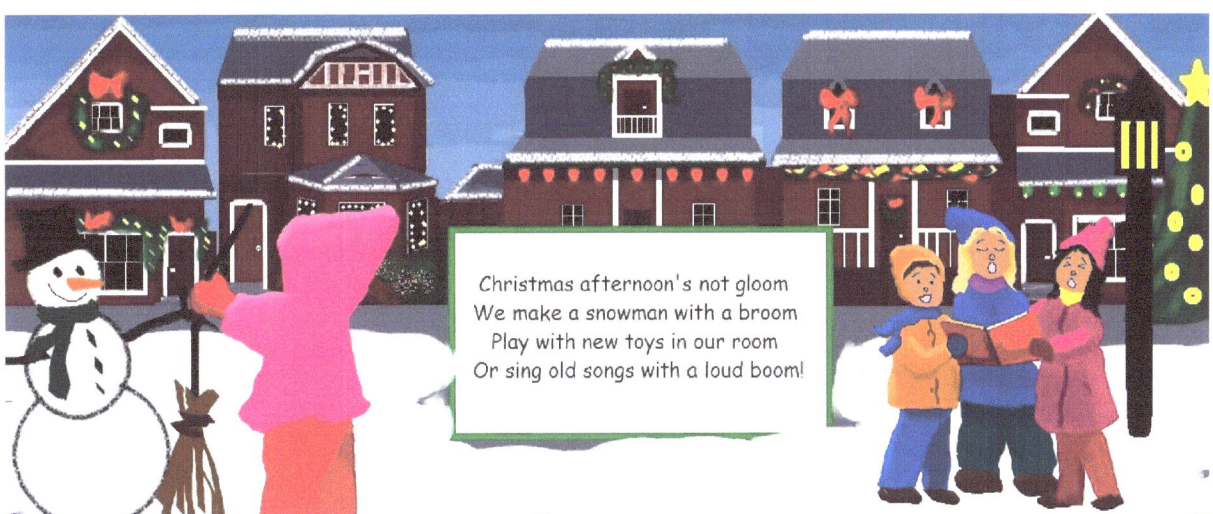

Real pictures, part two

For *Kitty and Company*, I looked to my own cats for inspiration. Since the book is also their real-life story, it helped me capture the characters' individual personalities. It's also a nice memory for me now; two of my cats have since passed away.

My sweeties:

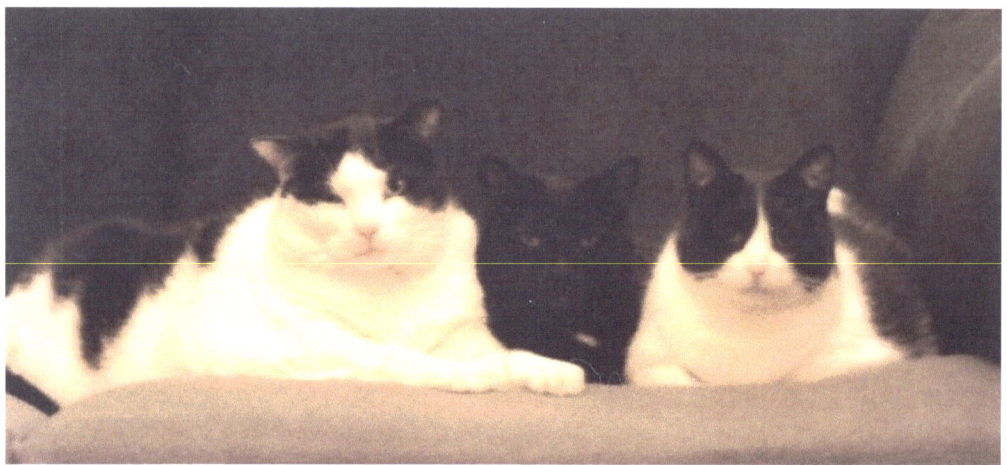

The characters:

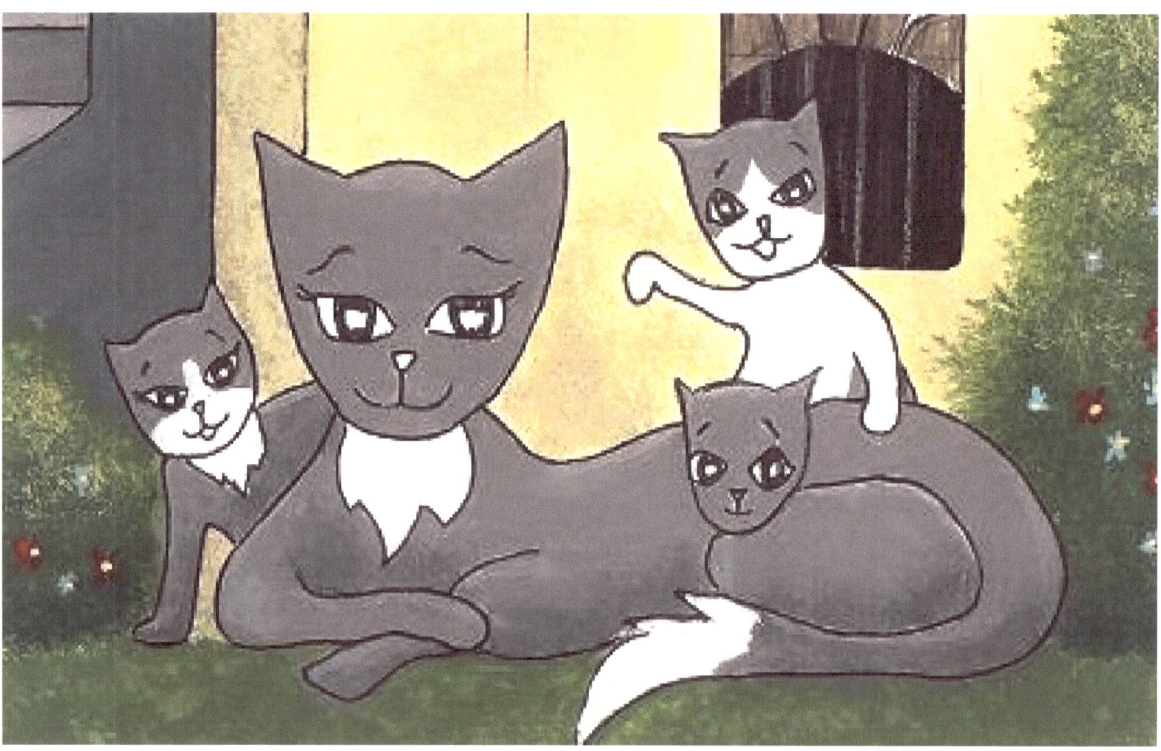

Problems with the canvas

I thought I needed something a little more sophisticated (ahem) for the covers of my young adult novels. This time, I decided I would work with real paint on a real canvas, then scan the end-result – but here I ran into some problems: the beautiful texture of the canvas transferred on my PC in full detail, complete with blotches of paint and uneven surface material, making for a hazy, "bubbly" look. I couldn't fix the problem, even on my PC, because that would've been too time-consuming. I had to make do with the less-than-perfect clarity of the images, but consoled myself with the thought that at least both novels, which are part of a series, have the same look…

One of the covers (and my poor attempt at hiding some of the blotches with my name and title):

On closer inspection…

Real paint... Real pain

There's a natural division between drawing literally (by hand, on paper) and drawing virtually (on your PC). Both techniques have pros and cons of course, but I personally prefer drawing by hand as it allows me to be much more precise, especially when it comes to facial expressions (where one misplaced dot can actually turn your character's smile into a frown). Over time however, I've also developed a taste for the perks of computer-painting. The Paint program in Office offers a wide range of artistic effects. Copying and pasting are par for the course, but you can also resize your picture, crop, mix and edit colors, and use any and all types of brushes. For instance:

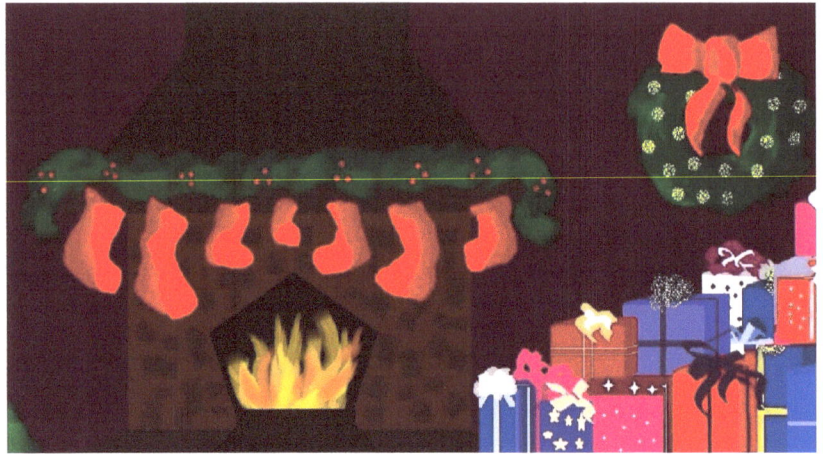

In this drawing, I used the oil brush for the wreath;
the watercolor brush for the flames;
the calligraphy brush to make the bows;
the marker for the ribbons on the presents;
the airbrush for the ornaments;
and the crayon to suggest masonry work on the fireplace.

The crayon was also great for making roof tiles on the Wizard's cottage.

In the same drawing, I used the oil brush for both the sky and the luscious grass landscape…

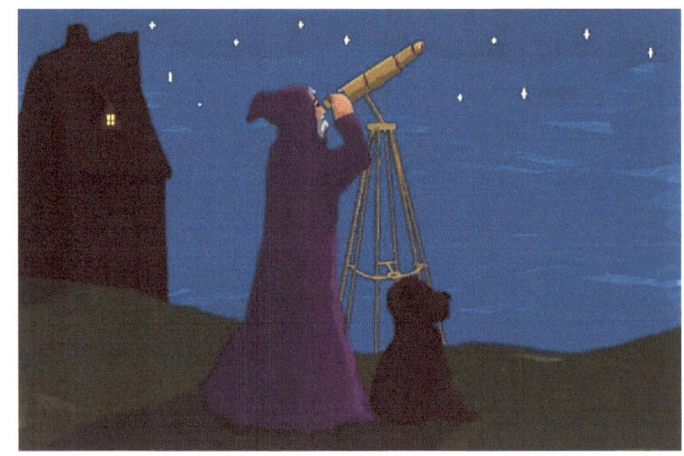

Another technique is to first draw by hand, then scan and retouch in Paint. After my disappointing experience with canvases, I tried using acrylic again, this time on a vellum surface Bristol paper. This is a thick drawing paper, usually used for dry media. It was the only drawing paper I had at the time but I found it worked well.

I used it for two books, scanned the drawings and then did touch-ups on my PC in Paint. Mistakes were easy to correct, erase or brush over. Paint allows you to use the exact same color from your hand-painted drawing through the aptly-named "color-picker".

The original drawing, with the entire left side missing…

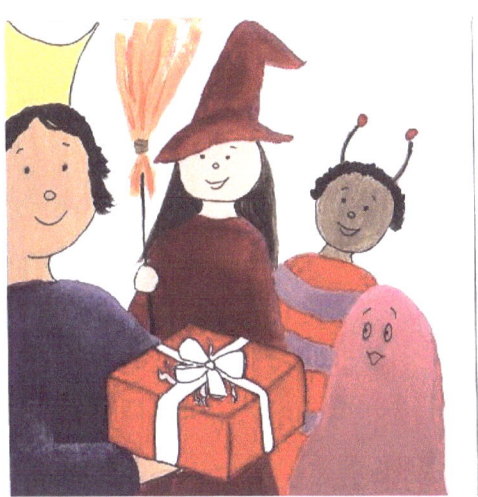

….and slightly retouched in Paint:

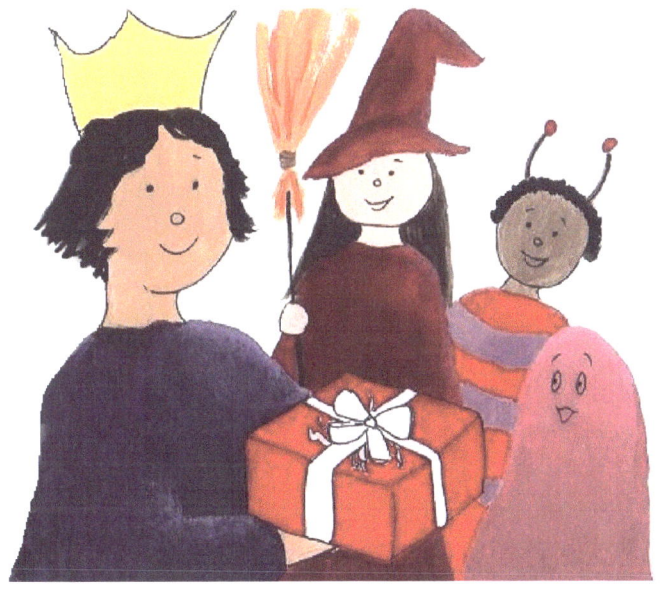

Another original drawing:

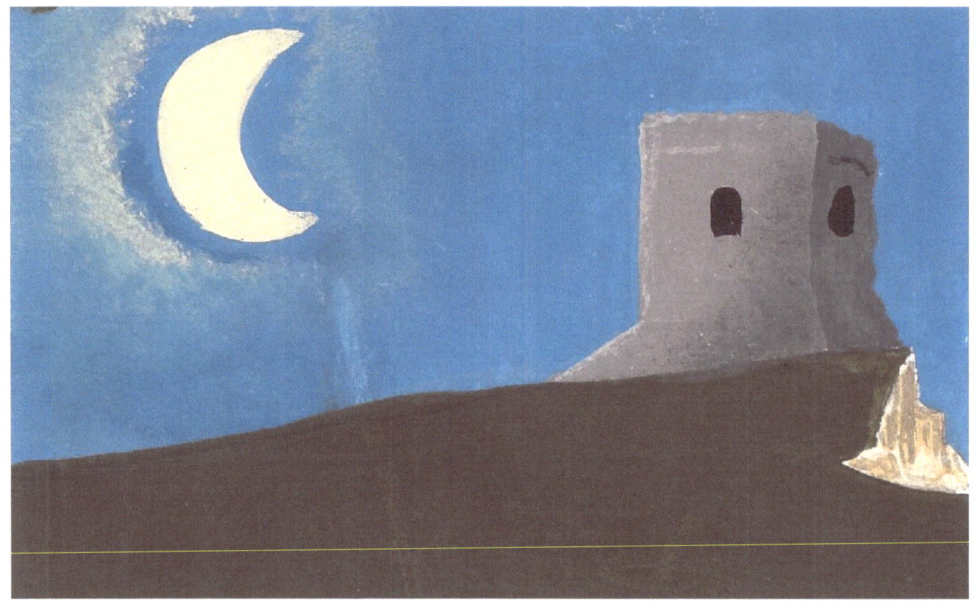

And then retouched in Paint:

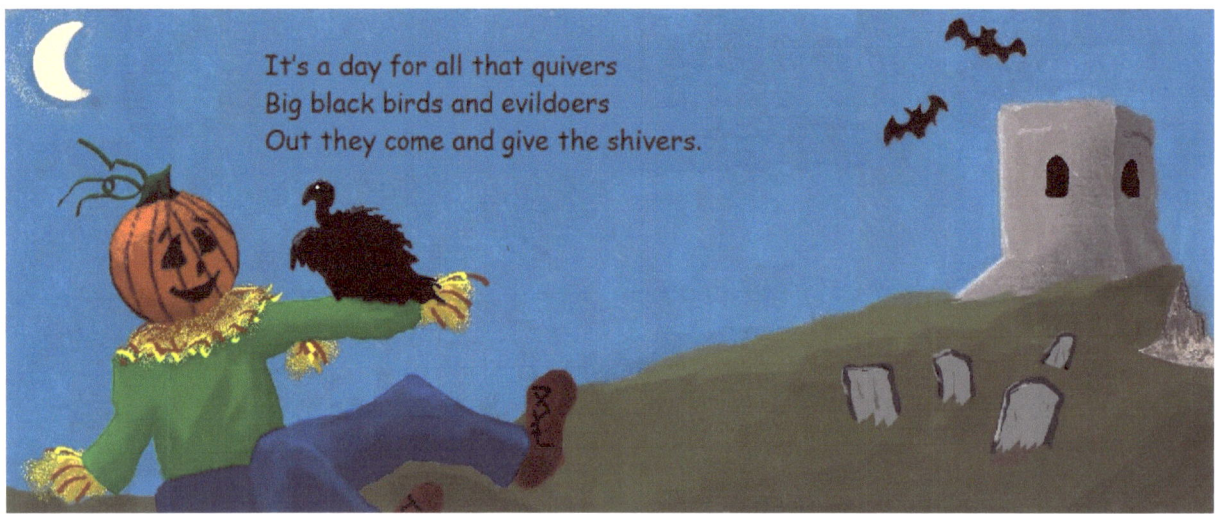

It's a day for all that quivers
Big black birds and evildoers
Out they come and give the shivers.

One of my very first attempts at using only Paint for the background:

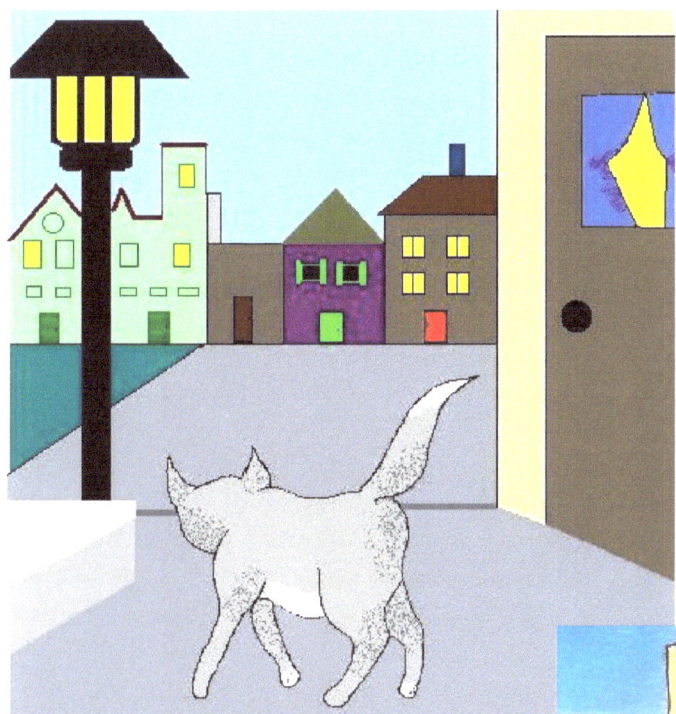

And the corrected version
(when, out of desperation,
I decided to go back to acrylic again):

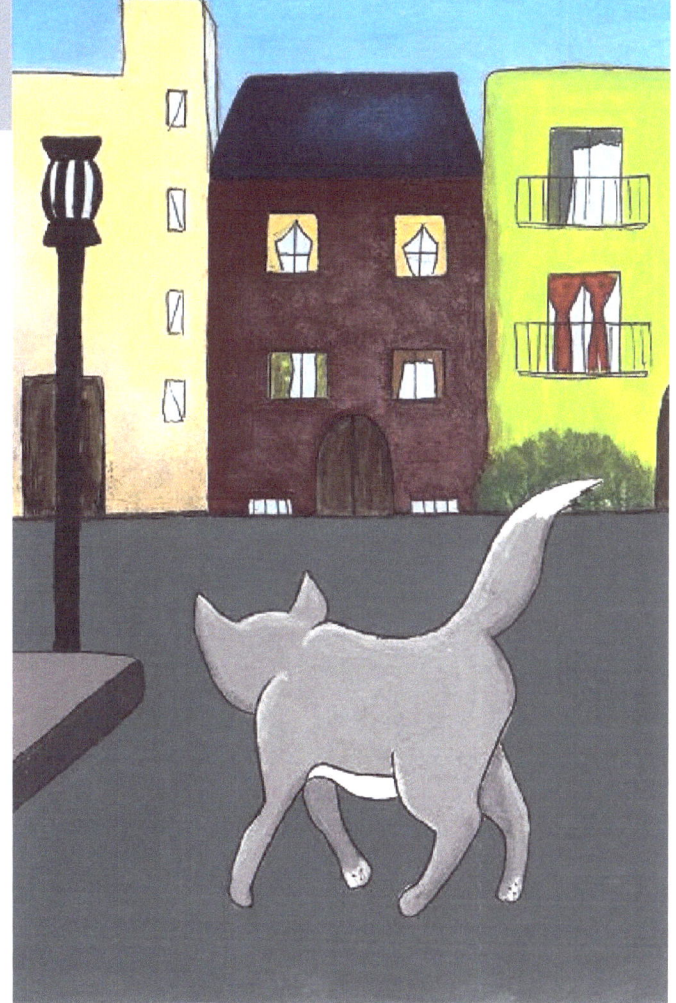

Painting in Layers

Just like "real" painting, drawing on your PC means working from depth to surface; start with your background and move forward, adding on details from back perspective to front perspective.

Sketch 1: basic idea

Sketch 2: the background

Sketch 3: add the characters

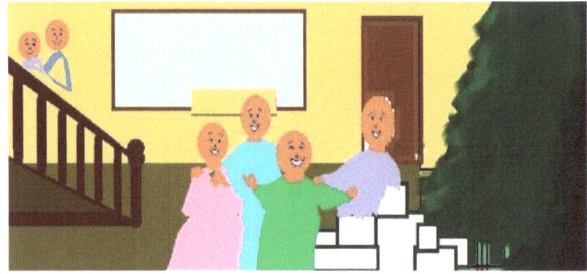

Sketch 4: add some details, change colors

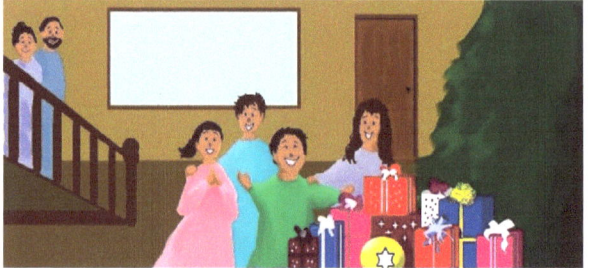

Sketch 5: more details, more color changes

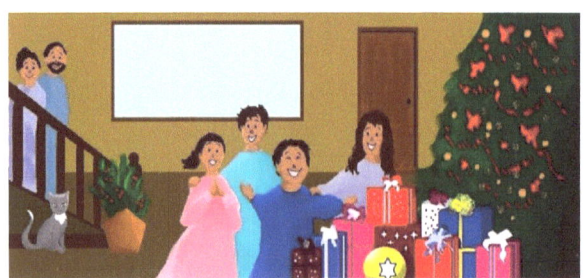

Sketch 6: add your text

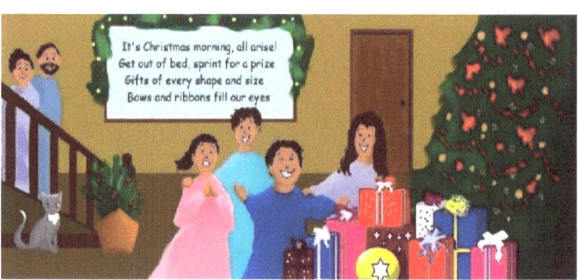

Painting in Layers, an encore

Another image in development:

Sketch 1:

Sketch 2:

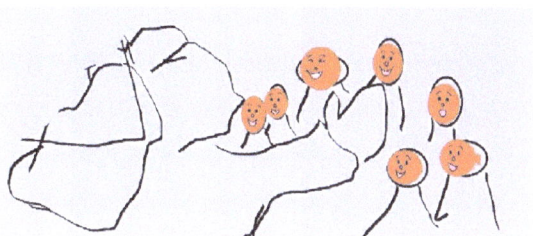

Sketch 3:

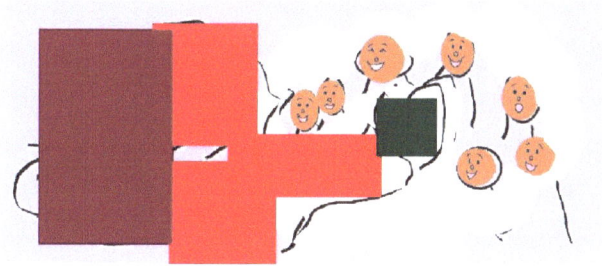

Sketch 4:

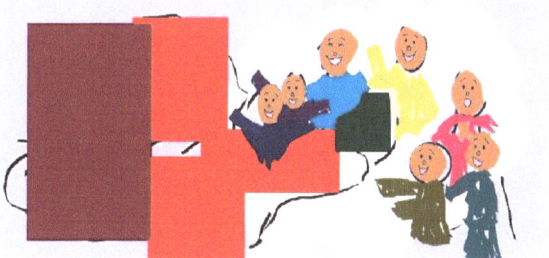

Sketch 9 (!):

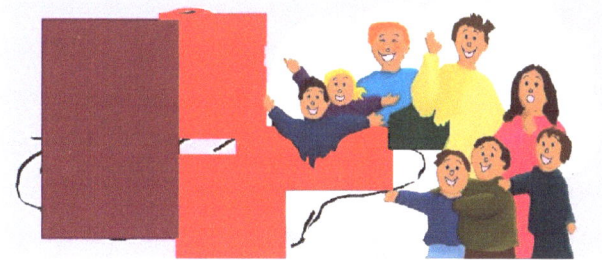

Sketch 13 (!!):

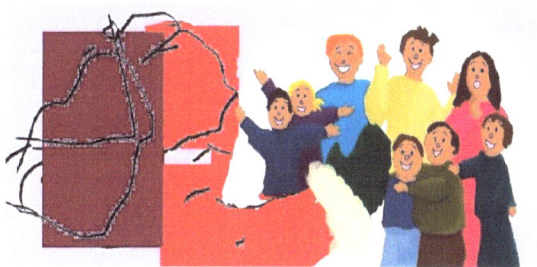

Sketch 17 (!!!):

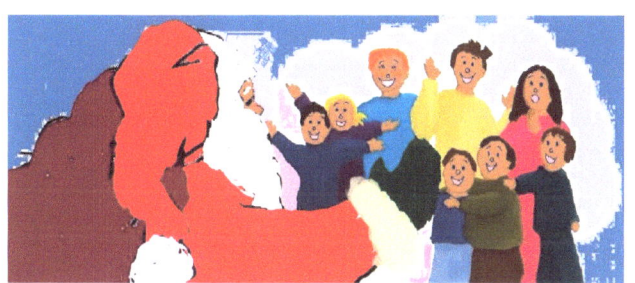

And final image (or sketch 21):

Note:

If you choose to add text over a drawing (instead of in a text box), make sure you save a version of that image without the text; this will make changes much easier to implement later on, either in the text or within the drawing itself.

Easy to change:

Not so easy:

Now it's your turn!

So now it's your turn to be creative! Stories for children's books are usually short and concise, with a lot of bright colors and vivid images, clear plot points and well-defined characters. I know writing – and drawing! – can be a challenge, but making your own book from scratch can be such a rewarding experience... It allows you to share your thoughts and feelings with other people in the simplest way possible, all the while exploring subjects and themes that matter to you most. So give yourself time to find your own voice and style – and, most of all, have fun!

www.ingramcontent.com/pod-product-compliance
Lightning Source LLC
Chambersburg PA
CBHW041319180526
45172CB00004B/1157